MW00710352

# NORTH CAROLINA
## TOTAL ECLIPSE GUIDE

### Commemorative Official
### Keepsake Guidebook

2017 Total Eclipse State Guide Series

Aaron Linsdau

# SASTRUGI PRESS

JACKSON HOLE

Copyright © 2017 by Aaron Linsdau

All rights reserved. No part of this book may be reproduced or transmitted in any form or by any means, electronic or mechanical, including photocopying, recording, or by any computer system without the written permission of the author, except where permitted by law.

Sastrugi Press / Published by arrangement with the author

*North Carolina Total Eclipse Guide: Commemorative Official Keepsake Guidebook*

The author has made every effort to accurately describe the locations contained in this work. Travel to some locations in this book is hazardous. The publisher has no control over and does not assume any responsibility for author or third-party websites or their content describing these locations, how to travel there, nor how to do it safely. Refer to official forest and national park regulations.

Any person exploring these locations is personally responsible for checking local conditions prior to departure. You are responsible for your own actions and decisions. The information contained in this work is based solely on the author's research at the time of publication and may not be accurate in the future. Neither the publisher nor the author assumes any liability for anyone climbing, exploring, visiting, or traveling to the locations described in this work. Climbing is dangerous by its nature. Any person engaging in mountain climbing is responsible for learning the proper techniques. The reader assumes all risks and accepts full responsibility for injuries, including death.

Park maps are courtesy of the National Park Service.

Sastrugi Press
PO Box 1297, Jackson, WY 83001, United States
www.sastrugipress.com
Quantity sales: Special discounts are available on quantity purchases by corporations, associations, and others. For details, contact the publisher at the address above.

Library of Congress Catalog-in-Publication Data
Library of Congress Control Number: 2017905389
Linsdau, Aaron
North Carolina Total Eclipse Guide / Aaron Linsdau-1st United States edition
p. cm.
1. Nature 2. Astronomy 3. Travel 4. Photography
Summary: Learn everything you need to know about viewing, experiencing, and photographing the total eclipse in North Carolina on August 21, 2017.

ISBN-13: 978-1-944986-14-8
ISBN-10: 1-944986-14-6

508.4—dc23

Printed in the United States of America

All photography, maps and artwork by the author, except as noted.

10 9 8 7 6 5 4 3 2 1

# Contents

# Introduction

Thank you for purchasing this book. It has everything you need to know about the total eclipse in North Carolina on August 21, 2017.

A total eclipse passing across the United States is a rare event. The last US total eclipse was in 1979. It traveled over Washington, Oregon, Montana, and the corner of North Dakota.

The next total eclipse over the US will not be until April 8, 2024. It will pass over Texas, the Midwest, and on to Maine. After that, the next coast-to-coast total eclipse will be in 2045!

It's imperative to make travel plans today. You will be amazed at the number of people swarming to the total eclipse path. Some might say watching a partial versus a total eclipse is a similar experience. It's not.

This book is written for North Carolina visitors and anyone else viewing the eclipse. You will find general planning, viewing, and photography information inside. Should you travel to the eclipse path in North Carolina in mid-August, be prepared for an epic trip. The state estimates a half million visitors will converge on North Carolina.

Some hotels in the communities and cities along the path of totality in North Carolina have already sold out as of the writing of this guide. Finding lodging along the eclipse path will be a major challenge.

Resources will be stretched far beyond the normal limits. Think gas lines from the late 1970s. It may be likely that traffic along mountain highways will come to a complete standstill during this event. Be prepared with backup supplies.

Many smaller North Carolina towns are far from any major city. North Carolina country roads are slow. Please obey posted speed limits within all forest and park areas. Be cautious about believing a map application's estimate of travel time in North Carolina.

People in all communities along the path of the total eclipse plan to rent out their properties for this event. With a major celestial event in the summer of 2017, be assured that North Carolina "hasn't seen anything yet."

Is this to say to avoid North Carolina or other areas during the eclipse? Not at all! This guidebook provides ideas for interesting,

alternative, and memorable locations to see the eclipse. It will be too late to rush to a better spot once the eclipse begins. Law enforcement will be out to help drivers reconsider speeding.

Please be patient and careful. There will be a large rush of people from all over the world converging on North Carolina to enjoy the total eclipse. Be mindful of other drivers on eclipse weekend, as they may not be familiar with North Carolina roads.

You should feel compelled to play hooky on August 21. Ask for the day off. Take your kids out of school. They'll likely be adults before the next chance to see a total eclipse. Create family memories that will last a lifetime. Sastrugi Press does not normally advocate skipping school or work. Make an exception because this is too big an event to miss.

Wherever you plan to be along the total eclipse path, leave early and remember your eclipse glasses. People from all around the planet will converge on North Carolina. Be good to your fellow humans and be safe. We all want to enjoy this spectacular show.

Visit www.sastrugipress.com/eclipse for the latest updates for this state eclipse book series.

### Author Information

Polar explorer and motivational speaker Aaron Linsdau's first book, *Antarctic Tears*, is an emotional journey into the heart of Antarctica. He ate two sticks of butter every day to survive. Aaron coughed up blood early in the expedition and struggled through equipment failures. Despite the endless difficulties, he set a world record for surviving the longest solo expedition to the South Pole.

Aaron teaches audiences how the common person can achieve uncommon results. He shares his techniques for overcoming adrenaline burnout and constant overload. He inspires audiences to face their challenges with a new perspective. Aaron builds grit, teaches courage, and shows how to maintain a positive attitude in the face of adversity. He hopes that you will be inspired and have an enjoyable time watching the total eclipse in North Carolina.

Visit his websites: www.aaronlinsdau.com and www.ncexped.com

# All About North Carolina

### OVERVIEW OF NORTH CAROLINA

North Carolina is place filled with such rich history and local culture. Formerly tagged as the "Variety Vacationland," North Carolina never fails to impress tourists and vacationers no matter what the season. So if you are planning for a weekend getaway or an academic adventure or better yet just a relaxing weekend at the beach, North Carolina should be given premium consideration on your list. Before, during, and after the total solar eclipse, the Tar Heel state's rich history and local culture will give you and your family a lifetime memory.

Rich in natural resources and subsistence, North Carolina has been home to early settlers, including around thirty Native American groups across the state. In the 1580s, the British attempted to institutionalize colonies in the state but failed. In the 1600s, settlers from

Virginia began to move to North Carolina and eventually became a part of the British colony then known as Carolina. In the year 1775, it became the first colony to declare independence from Great Britain, and after the historical American Revolution, the newly independent state became the twelfth member of the Union. Today a lot of those historical narratives and remnants still exist in North Carolina, currently being patronized by tourists and visitors from around the world.

Luckily, North Carolina has been fortunate enough to preserve various collections of both natural and man-made amenities, luring millions of tourists and visitors around the world. There are several locations in the state beyond the path of the total eclipse that are worth seeing.

Located on Lodge Street in Asheville, North Carolina, the Biltmore Estate is considered a place that you should visit the moment you step into the state. The Estate is measured 8,000 acres wide, and at its center sits the Vanderbilt Mansion, containing 250 rooms filled with artwork, antiques, and colonial architecture. Along the premises, visitors are encouraged to walk through its beautiful handicraft gardens and the River Bend Farm.

Located in Wilmington, North Carolina, the battleship USS North Carolina is known as the first of ten to join the American fleet way back during World War II. Commissioned on April 9, 1941, the vessel has been preserved with its well-armed nine 16-inch/45-caliber guns in its three turrets as well as twenty pieces of 5-inch/38-caliber guns in its mounts. The battleship was known as the world's greatest sea weapon. Today she attracts tourists that are allowed to roam around the ship through its mess hall, as well as the sailors' and officers' quarters for a glimpse of what it was like sailing during the War.

The state's Old Cardinal Gem Mine is actually known to be the World's Mining Capital where geologists situated around the globe can dig for treasures and materials for research. However, this location is unique in that visitors are allowed to dig through the dirt too! The mine has now been operating for more than forty years, attracting academics and tourists year-round. Believe it or not, visitors have never failed to enjoy themselves by the mining experience. After they conduct their "treasure hunt," staff in the vicinity will help the tourists weigh and identify the gems they managed to find, as well as help them bag them up to bring home for remembrance. The Old Cardinal Gem is described as a fun, family and kid-friendly attraction that will keep you busy and thrilled the whole day.

The Morehead Planetarium and Science Center is a place that should be on your must-see list during your North Carolina visit, especially before or after the total solar eclipse. Located in Chapel Hill at the University of North Carolina, this institution has lured more than seven million visitors since its inception in 1949. In addition to the regular yet various programs held there, activities at the center have been created to provide lessons on planets, bright stars, and constellations.

Aside from these academic and historical attractions and destinations, North Carolina also houses various nature and water parks that are fit for adventure and outdoor enthusiasts. Whether you plan to travel to North Carolina before or after the eclipse, you'll have family memories to enjoy for a lifetime.

### HOTELS AND MOTELS DURING THE ECLIPSE

Once word of the total eclipse over North Carolina spreads, rooms will become scarce. Many hotels in towns along the path of totality in western states have been sold out for a year or more. North Carolina is not alone in this challenge. Hotels in Idaho and Wyoming have been sold out for multiple years in anticipation of the total eclipse.

What does this mean for eclipse visitors? Lodging and room rentals in eclipse towns will be at a massive premium. Does that mean all hope is lost to find a place to stay? Not at all. But you will have to be creative. There will be few if any hotel rooms available in these eclipse cities by the time this book is printed. Accommodations in the cities and towns along the path of the eclipse have been sold out for months.

In spring 2017, the author searched on Hotels.com for rooms along the total eclipse path on the weekend of August 21 and found options still available. Once word of the eclipse spreads, room rates will increase and availability will drop.

Search for rooms farther away from the eclipse path. If you are willing to stay in cities outside the eclipse path, you will have better success at finding rooms. As the eclipse approaches, people will book rooms farther from the totality path. By midsummer, rooms in cities along the total eclipse path may be unavailable. The effect of this event will be felt across North Carolina and the rest of the United States.

Think regionally when looking for rooms. Be prepared to search far and wide during this major event. If a five-hour drive is manageable, your lodging options greatly expand, but it also increases your travel risk.

### INTERNET RENTALS

To find rooms to stay in towns along the eclipse path, try a web service such as Airbnb.com. Note that many people rent out rooms or homes illegally, against zoning regulations. Many cities have already

begun to feel the crunch of eclipse inquiries.

If North Carolina towns fully enforce zoning laws, authorities may prevent your weekend home rental. Online home rentals during the eclipse will be a target for rental scams. People from out of the area steal photos and descriptions, then post the home for rent. You send your check or wire money to a "rental agent" then show up to find you have been scammed. If the deal sounds strange or too good to be true, run away.

## CAMPING

If you can book a campsite, do it now. Do not wait. All areas in the national forests are first-come, first-served. Forest roads will be packed. Expect all areas to be swarming with people. Show up early to stake out your spot. Consider staying farther away and driving early on August 21.

Please respect private land too. North Carolina folks don't take kindly to people overrunning their property without permission. In a big state with over ten million residents, people are very protective, but they're friendly, too. You never know what you might be able to arrange with a smile and a bit of money.

This all said, there are plenty of camping opportunities throughout North Carolina. You don't have to sleep exactly on the eclipse path. If you're ready to rough it, there are national forest camping options.

Government agencies have been meeting since 2015 to talk about how to manage the influx of people. Every possible government agency will be working full time to enforce the various rules and regulations.

## NATIONAL PARKS AND MONUMENTS

Chances are finding a camping site at any state park, national park, or national monument in North Carolina will be challenging. To watch the eclipse from any location, you do not have to sleep in it. You just need to drive there in the morning.

Law enforcement will be present on the eclipse weekend. Hundreds of thousands of people are expected in the region. Parking will overflow. It will make parking lots and lines on Black Friday at the mall look uncrowded. For an event of this magnitude, find parking early.

The first sentence of the national parks mission statement is:

*"The National Park Service preserves unimpaired the natural and cultural resources and values of the national park system for the enjoyment, education, and inspiration of this and future generations."*

Roadside camping (sleeping in your car) is not allowed in national monuments or parks. Park facilities are only designed to handle so many people per day. Water, trash collection, and toilets can only withstand so much. If you notice trash on the ground, take a moment to throw it away. Protect your national park and help out. Rangers are diligent and hardworking but they can only do so much to manage the expected crowds.

### NATIONAL FORESTS AND WILDERNESS

There are national forest options in North Carolina. They all have camping opportunities. The forest service manages undeveloped and primitive campsites. Be sure to check for any fire restrictions. Check with individual agencies for last-minute information and regulations. The forest service requires proper food storage. Plan to purchase food and water before choosing your campsite. Below is a partial list of national forests along or near the total eclipse path:

Nantahala NF:
     www.fs.usda.gov/recarea/nfsnc/recarea/?recid=48634
Pisgah NF:
     www.fs.usda.gov/recarea/nfsnc/recarea/?recid=48114
Joyce Kilmer-Slickrock Wilderness

Backcountry service roads abound in North Carolina. Maps for forests are available at local visitor centers and bookstores. This book's website has digital copies of some forest maps.

Printed national forest maps are large and detailed. They have illustrated road paths, connections, and other vital travel information not available on digital device maps. Viewing digital maps on your

smartphone or iPad is difficult. If you plan to camp in the forest, a real paper map is a wise investment.

Camping in federal wilderness areas is also allowed. Those areas afford the ultimate backcountry experience. However, be aware that no vehicle travel is allowed in the specially designated areas. This ban includes: vehicles, bikes, hang gliders, and drones. You can travel only on foot or with pack animals.

### SLEEP IN YOUR CAR

Countless RVs, campers, trucks, cars, and motorcycles will flood North Carolina. Sleeping in your car with friends is tolerable. Doing so with unadventurous spouses or children is another matter.

Do not be caught along the path of the total eclipse without some sort of plan, especially in the bigger cities of North Carolina. The whole path of totality will fill with people on August 21.

### USEFUL LOCAL WEBCAMS

Local webcams are handy to make last-minute travel decisions. The webcams are sensitive enough to show headlights at night. Use them to determine if there are issues before traveling out. Eclipse traffic will add to the morning commuter traffic.

The smartphone application Wunderground is useful to check on webcams in one place. All the webcams are listed in the app.

## Weather

It's all about the weather during the eclipse. Nothing else will matter if the sky is cloudy. You can be nearly anywhere in North Carolina and catch a view of the sky when traffic comes to a standstill. But if there's a cloud cover forecast, seriously reconsider your viewing location.

Travel early wherever you plan to go. Attempting to change locations an hour before the eclipse due to weather will likely cause you to miss the event. North Carolina country roads can be narrow and slow. The number of vehicles will cause unexpected backups.

## MODERN FORECASTS

Use a smartphone application to check the up-to-date weather. Wunderground is a good application and has relatively reliable forecasts for the region. The hourly forecast for the same day has been rather accurate for the last two years. The below discussion refers to features found in the Wunderground app. However, any application with detailed weather views will improve your eclipse forecasting skills.

## CLOUD COVER FORECAST

The most useful forecast view is the visible and infrared cloud-coverage map. Avoid downloading this app the night before and trying to

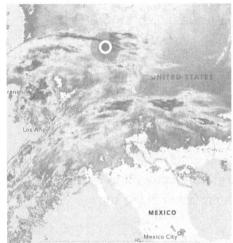

learn how to read it. Practice reading them at home. It's imperative to understand how to interpret the maps early.

All cloud cover, night or day, will appear on an infrared map. Warm, low-altitude clouds are shown in white and gray. High-altitude cold clouds are displayed in shades of green, yellow, red, and purple. Anything other than a clear map spells eclipse-viewing problems.

To improve your weather guess, use the animated viewer of the cloud cover. It will give you a sense of cloud motion. You can discern whether clouds or rain are moving toward, away from, or circulating around your location.

Infrared cloud map showing the worst case eclipse cloud cover.
Courtesy of National Weather Service.

## NORMAL NORTH CAROLINA WEATHER PATTERN

Due to the direction of the jet stream, most weather travels across the Pacific Ocean, through the western states, over Missouri and Kentucky, and then into North Carolina. On occasion, weather can approach from any direction. Due to the nature of the tropical storms

from the Atlantic, weather in North Carolina can be unpredictable.

The common weather pattern in August is hot and humid. Passing cold fronts in summer can bring unexpected cloud cover.

Cities in North Carolina tend to have variable clouds during August. Prepare to make adjustments. If anything other than clear skies are predicted, plan to drive to other parts of Tennessee, South Carolina, North Carolina, or Georgia.

Be aware of tornadoes in North Carolina. Although the peak tornado season is June, there have been many recorded tornadoes in August. Pay attention to the weather forecast. If dangerous weather is predicted, your main concern should be safety rather than chasing an eclipse.

Consider that slow-moving clouds can obscure the sun for far longer than the two-minute duration of the totality. The time of totality is so short that you do not want to risk it. Missing it due to a single cloud will be a major disappointment.

### LOCAL ECLIPSE WEATHER FORECASTS

Local town and city newspapers, radio, and television stations around North Carolina will have a weekend edition with articles discussing the eclipse weather. However, conditions change unpredictably in North Carolina. A three-day forecast may be incorrect.

### FOREST FIRES

For the past several years, forest fires have been common in the United States. The summer of 2017 is likely to be no different. There were fires in the forests North Carolina during spring 2017. Chances are there will be fires again in the region in the summer of 2017. For fire updates check:

inciweb.nwcg.gov

For the best eclipse viewing experience, you need to have as clear a sky as possible. Fog, clouds, or smoke will

obscure the subtleties of the sun's corona. If you think the view of the sky is going to be blocked, don't wait until the last minute to move to a clearer location. If you wait too long to decide to move to a better viewing area, it may be impossible due to traffic.

### ROAD CLOSURES DUE TO FIRES

Highways connecting various North Carolina towns can be closed during a major fire. The Rock Mountain Fire and Camp Branch Fire blackened North Carolina skies. There were other fires at the same time, too.

With unpredictable weather in the last few years, it's a guess what will happen in August 2017. If forest areas continue to remain dry, the whole region may have many fires.

Although fire is an important part of forest ecology, it worries eclipse chasers. Other than clouds, smoke from fires will block the view of the sun and moon on the morning of the eclipse. Should there be fires where you are or may be headed, reconsider your location as early as possible. The most accurate website for fires is:

inciweb.nwcg.gov

Check the North Carolina road report for updated information:

tims.ncdot.gov/tims/

It's imperative to plan for fires and their effects. Watch the weather reports. If strong winds and lightning storms are forecast, prepare to change your viewing location. If conditions are poor, you and thousands of other vehicles will be trapped in slow-moving traffic.

If you believe it's necessary to leave a town to watch the eclipse, do so the night before or extremely early in the morning. RVs are common, and trains of them crawl through popular areas.

# North Carolina Information

### CELLULAR PHONES

Cellular "cell" phone service in remote North Carolina locations is spotty at best. Most of the time there is good coverage along the main highways and interstates. However, even along major thoroughfares,

there can be little or no coverage.

It's possible to find zones where text messages will send when phone calls are impossible. If you cannot make a phone call, the chance of having data coverage for web surfing or e-mail is low.

Please look up any information or communicate what you need before departing from the main roads around North Carolina. Bureau of Land Management (BLM) areas sometimes have coverage. Planned to be self-contained. Treat like your cell phone like it won't connect.

You may find yourself out of cell service. With a large number of cell users in a concentrated area, coverage and data speed may collapse as well. Search on the phrase "cell phone coverage breathing".

## Wilderness and Forest Safety

All North Carolina forests are full of wild animals. Although beautiful, wild animals can be dangerous. They can easily injure or kill people, as they are far more powerful than humans. Do not try to feed any wild animals, including squirrels, foxes, and chipmunks, as they can carry diseases. These suggestions apply to all public lands.

### Bears

The forests of North Carolina are home to black bears. Safety is imperative around these powerful animals. Although they often appear docile, they can become aggressive if threatened. In the unlikely event of an attack, fight back against the bear. Use whatever you have at your disposal to defend yourself. Report all negative or aggressive bears to the local authorities.

If a bear hears you, it will usually vacate the area. Bear charges are often caused by unexpected and surprise encounters. Noise is the best defense to avoid surprising bears. Regularly clap, make noise, and talk loudly. The North Carolina Wildlife Commission Agency website has more specific information on safety and food management in bear country at www.ncwildlife.org/portals/0/learning/documents/species/coexistwithbears.pdf. Stay one hundred yards (300 feet) away from all bears. They are exciting to see but need their space. Refer to current forest or park regulations for more safety information.

## RATTLESNAKES

There are several primary species of rattlesnakes in North Carolina: Timber Rattlesnake, Copperhead, and Eastern Diamondback, Cottonmouth, and Pygmy Rattlesnake, Cottonmouth, and Coral snakes. Although these reptiles are not generally aggressive, they can strike when provoked or threatened. Of the approximately 8,000 people annually bitten by venomous snakes in the United States, ten to fifteen people die according to the U.S. Food and Drug Administration.

The best way to avoid rattlesnake encounters is to be mindful of your environment. Do not place your hands or feet in locations where you cannot clearly see the surroundings. Avoid heavy brush or tall weeds where snakes hide during the day. Step on a log or rock rather than over it, as a hidden snake might be on the other side. Rattlesnakes may not make any noise before striking.

Avoid handling all rattlesnakes. Should you be bitten, stay calm and call 911 or emergency dispatch as soon as possible. Transport the victim to the nearest medical facility immediately. Rapid professional treatment is the best way to manage rattlesnake bites. Refer to US Forest Service and professional medical texts for more information on managing rattlesnakes injuries.

## TICKS

Ticks exist all across the United States but not all species transmit disease. Ticks cannot fly or jump, but they climb grasses in shrubs in order to attach to people or animals that pass by. Ticks feed on the blood of their host. In doing so, they can transmit potentially life-threatening diseases such as Lyme disease.

According to the National Pesticide Information Center, ticks must be attached and feed for several hours before an infection can be passed. Do not wait that long to manage tick exposure. As soon as you travel through outdoor locations, especially in grasses or shrubs, check yourself for ticks. They can be incredibly small and difficult to detect. Some are smaller than the head of a pin.

You may wish to consider wearing tick-specific insect repellent. Check with your doctor or medical professional about any potential adverse side effects of chemical repellents.

Should you discover an attached tick, follow modern tick removal methods. There are many incorrect tick removal methods found on-line. Refer to your medical professional for proper removal methods. Improper removal increases the likelihood of an infection.

### MOUNTAIN LIONS

Though listed as exctinct, there have been recent reports of mountain lions in North Carolina. If you encounter a mountain lion, do not run. Keep calm, back away slowly, and maintain eye contact. Do all you can to appear larger. Stand upright, raise your arms, or hoist your jacket. Never bend over or crouch down. If attacked, fight back.

# Eclipse Day Safety

### 1. Hydrate
Summers can be extremely warm. The excitement of the event can distract you from managing hydration. Drink plenty of water. Consume more than you would at home.

### 2. Eye Safety time
Use certified eclipse safety glasses at all times when viewing the partial eclipse. Only remove the glasses when the totality happens. Give your eyes time to rest. Even though the glasses are safe, your eyes can dry out and become irritated. Bring FDA approved eye drops to keep your eyes moist.

### 3. Sun exposure
The sun is much more intense in August. Wear sunglasses and liberally apply sunscreen to avoid sunburns.

### 4. Eat well
Keep your energy up. Appetite loss is common when traveling. Maintain your normal eating schedule.

### 5. Prepare for temperature changes
Temperatures will drop rapidly once the sun sets, especially in the mountains or forests. Bring appropriate clothing.

### 6. Talk with your doctor
If the humidity or heat bothers you talk with your doctor before traveling. Seek professional medical attention for serious symptoms.

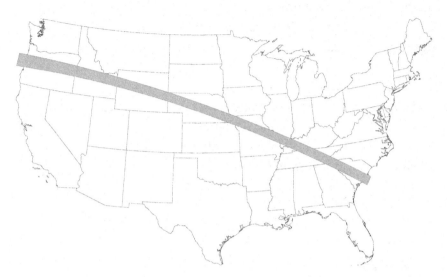

Total eclipse path across the United States (approximate).

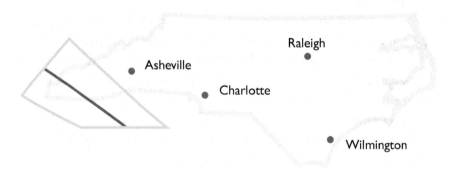

Total eclipse path across North Carolina (approximate).

# All About Eclipses

### How an Eclipse Happens

An eclipse occurs when one celestial body falls in line with another, thus obscuring the sun from view. This occurs much more often than you'd think, considering how many bodies there are in the solar system. For instance, there are over 150 moons in the solar system. On Earth, we have two primary celestial bodies: the sun and the moon. The entire solar system is constantly in motion, with planets orbiting the sun and moons orbiting the planets. These celestial bodies often come into alignment. When these alignments cause the sun to be blocked, it is called an eclipse.

For an eclipse to occur, the sun, Earth, and moon must be in alignment. There are two types of eclipses: solar and lunar. A solar eclipse occurs when the moon obscures the sun. A lunar eclipse occurs when the moon passes through Earth's shadow. Solar eclipses are much more common, as we experience an average of 240 solar eclipses a century compared to an average of 150 lunar eclipses. Despite this, we are more likely to see a lunar eclipse than a solar eclipse. This is due to the visibility of each.

For a solar eclipse to be visible, you have to be in the moon's shadow. The problem with viewing a total eclipse is that the moon casts a small shadow over the world at any given time. You have to be in

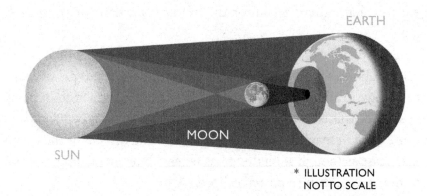

EARTH

MOON

SUN

* ILLUSTRATION
NOT TO SCALE

a precise location to view a total eclipse. The issue that arises is that most of these locations are inaccessible to most people. Though many would like to see a total solar eclipse, most aren't about to set sail for the middle of the Pacific Ocean. In fact, a solar eclipse is visible in the same place on the world on average every 375 years. This means that if you miss a solar eclipse above your hometown, you're not going to see another one unless you travel or move.

It's much easier to catch a glimpse of a lunar eclipse, even though they occur at a much lower frequency than their solar counterparts. A lunar eclipse darkens the moon for a few hours. This is different than a new moon when it faces away from the sun. During these eclipses, the moon fades and becomes nearly invisible.

Another result of a lunar eclipse is a blood moon. Earth's atmosphere bends a small amount of sunlight onto the moon turning it orange-red. The blood moon is caused by the dawn or dusk light being refracted onto the moon during an eclipse.

Lunar eclipses are much easier to see. Even when the moon is in the shadow of Earth, it's still visible throughout the world because of how much smaller it is than Earth.

## Total vs. Partial Eclipse

What is the difference between a partial and total eclipse? A total eclipse of either the sun or the moon will occur only when the sun, Earth, and the moon are aligned in a perfectly straight line. This ensures that either the sun or the moon is partially or completely obscured.

In contrast, a partial eclipse occurs when the alignment of the three celestial bodies is not in a perfectly straight line. These types of eclipses usually result in only a part of either the sun or the moon being obscured. This is often what led to ancient civilizations believing that some form of magical beast or deity was eating the sun or the moon. It appears as though something has taken a bite out of either the sun or the moon during a partial eclipse.

Total eclipses, rarer than partial eclipses, still occur quite often. It's more difficult for people to be in a position to experience such an event firsthand. Total solar eclipses can only be viewed from a small portion of the world that falls into the darkest part of the moon's shadow. Often this happens in the middle of the ocean.

### THE MOON'S SHADOW

The moon's shadow is divided into two parts: the umbra and the penumbra. The former is much smaller than the latter, as the umbra is the innermost and darkest part of the shadow. The umbra is thus the central point of the moon's shadow, meaning that it is extremely small in comparison to the entire shadow. For a total solar eclipse to be visible, you need to be directly beneath the umbra of the moon's shadow. This is because that is the only point at which the moon completely blocks the view of the sun.

In contrast, the penumbra is the region of the moon's shadow in which only a portion of the light cast by the sun is obscured. When

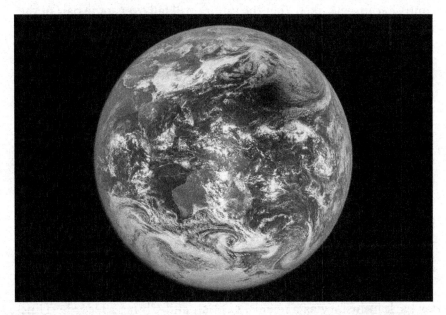

Total eclipse shadow 2016 as seen from 1 million miles on the Deep Space Climate Observatory satellite. Courtesy of NASA.

standing in the penumbra, you are viewing the eclipse at an angle. In the penumbra, the moon does not completely block the sun from view. This means that while the event is a total solar eclipse, you'll only see a partial eclipse. The umbra for the August 21st eclipse is approximately sixty miles wide. The penumbra will cover much of the United States.

To provide some context, the last total solar eclipse we experienced occurred on March 9, 2016, and was visible as a partial eclipse across most of the Pacific Ocean, parts of Asia, and Australia. However, the only place in the world to view this total solar eclipse was in a few parts of Indonesia.

Due to the varied locations and the brief periods for which they're visible, it's difficult to see each and every eclipse that occurs. Many people don't even realize that they have occurred. Consider that the umbra of the moon represents such a small fraction of the entire shadow and the majority of our planet is comprised of water. Thus, the rarity of being able to view a total solar eclipse increases significantly because it's likely that the umbra will fall over some part of the ocean rather than a populated landmass.

## ECLIPSES THROUGHOUT HISTORY

Ancient peoples believed eclipses were from the wrath of angry gods, portents of doom and misfortune, or wars between celestial beings. Eclipses have played many roles in cultures, creating myths since the dawn of time. Both solar and lunar eclipses affected societies worldwide. Inspiring fear, curiosity, and the creation of legends, eclipses have cast a long shadow in the collective unconscious of humanity throughout history.

## EARLY MYTH & ASTRONOMY

Documented observations of solar eclipses have been found as far back in history as ancient Egyptian and Chinese records. Time-keeping was important to ancient Chinese cultures. Astronomical

observations were an integral factor in the Chinese calendar. The first observation of a solar eclipse is found in Chinese records from over 4,000 years ago. Evidence suggests that ancient Egyptian observations may predate those archaic writings.

Many ancient societies, including Roman, Greek and Chinese civilizations, were able to infer and foresee solar eclipses from astronomical data. The sudden and unpredictable nature of solar eclipses had a stressful and intimidating effect on many societies that lacked the scientific insight to accurately predict astronomical events. Relying on the sun for their agricultural livelihood, those societies interpreted solar eclipses as world-threatening disasters.

In ancient Vietnam, solar eclipses were explained as a giant frog eating the sun. The peasantry of ancient Greece believed that an eclipse was the sign of a furious godhead, presenting an omen of wrathful retribution in the form of natural disasters. Other cultures were less speculative in their investigations. The Chinese Song Dynasty scientist Shen Kuo proved the spherical nature of the Earth and heavenly bodies through scientific insight gained by the study of eclipses.

## THE ECLIPSE IN NATIVE AMERICAN MYTHOLOGY

Eclipses have played a significant role in the history of the United States. Before Europeans settled in the Americas, solar eclipses were important astronomical events to Native American cultures. In most native cultures, an eclipse was a particularly bad omen. Both the sun and the moon were regarded as sacred. Viewing an eclipse, or even being outside for the duration of the event, was considered highly taboo by the Navajo culture. During an eclipse, men and women would simply avert their eyes from the sky, acting as though it was not happening.

The Choctaw people had a unique story to explain solar eclipses. Considering the event as the mischievous actions of a black squirrel and its attempt to eat the sun, the Choctaw people would do their best to scare away the cosmic squirrel by making as much noise as

possible until the end of the event, at which point cognitive bias would cause them to believe they'd once again averted disaster on an interplanetary scale.

## Contemporary American Solar Phenomena

The investigation of solar phenomena in twentieth-century American history had a similarly profound effect on the people of the United States. A total solar eclipse occurring on the sixteenth of June, 1806, engulfed the entire country. It started near modern-day Arizona. It passed across the Midwest, over Ohio, Pennsylvania, New York, Massachusetts, and Connecticut. The 1806 total eclipse was notable for being one of the first publicly advertised solar events. The public was informed beforehand of the astronomical curiosity through a pamphlet written by Andrew Newell entitled *Darkness at Noon, or the Great Solar Eclipse.*

This pamphlet described local circumstances and went into great detail explaining the true nature of the phenomenon, dispelling myth and superstition, and even giving questionable advice on the best methods of viewing the sun during the event. Replete with a short historical record of eclipses through the ages, the *Darkness at Noon* pamphlet is one of the first examples of an attempt to capitalize on the mysterious nature of solar eclipses.

Another notable American solar eclipse occurred on June 8, 1918. Passing over the United States from Washington to Florida, the eclipse was accurately predicted by the U.S. Naval Observatory and heavily documented in the newspapers of the day. Howard Russell Butler, painter and founder of the American Fine Arts Society, painted the eclipse from the U.S. Naval Observatory, immortalizing the event in *The Oregon Eclipse.*

Four more total solar eclipses occurred over the United States in the years 1923, 1925, 1932, and 1954, with another occurring in 1959. The October 2, 1959, solar eclipse began over Boston, Massachusetts. It was a sunrise event that was unviewable from the ground level. Em-

inent astronomer Jay Pasachoff attributed this event to sparking his interest in the study of astronomy. Studying under Professor Donald Menzel of Williams College, Pasachoff was able to view the event from an airline hired by his professor.

To this day, many myths surround the eclipse. In India, some local customs require fasting. In eastern Africa, eclipses are seen as a danger to pregnant women and young children. Despite the mystery and legend associated with unique and rare astronomical events, eclipses continue to be awe-inspiring. Even in the modern day, eclipses draw out reverential respect for the inexorable passing of celestial bodies. They are a reminder of the intimate relationship between the denizens of Earth and the universe at large.

## PRESENT DAY ECLIPSES

The year 2016 brought the world just two solar eclipses. A total solar eclipse occurred on the 9th of March. An annular solar eclipse, in which the sun appears as a "ring of fire" occurred on the 23rd of March. If you're interested in seeing this rare and exciting solar

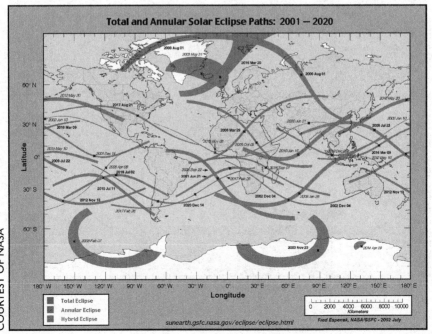

COURTESY OF NASA

phenomenon yourself, you must to travel to either South America or Western Africa on the 26th of February, 2017.

The next total solar eclipse viewable from the United States, or anywhere else in the world, will occur on the 21st of August, 2017. It will be visible in Oregon, Idaho, Wyoming, Nebraska, Kansas, Missouri, Illinois, Kentucky, Tennessee, Georgia, North Carolina, and South Carolina. The event will be the only total solar eclipse for Americans this decade.

### FUTURE AMERICAN ECLIPSES

The next total eclipse to cross the continental United States is on April 8, 2024. It will travel from Texas to Maine. After that, the next American total eclipses will be in 2044 and 2045.

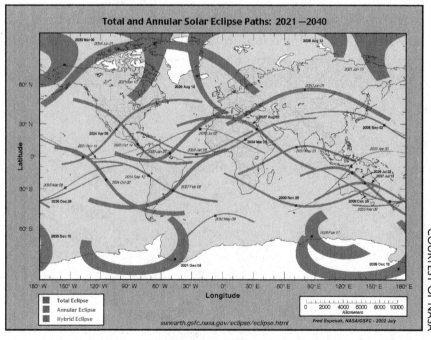

COURTESY OF NASA

# Viewing and Photographing the Eclipse

### AT-HOME PINHOLE METHOD

Use the pinhole method to view the eclipse safely. It costs little but is the safest technique there is. Take a stiff piece of single-layer cardboard and punch a clean pinhole. Let the sun shine through the pinhole onto another piece of cardboard. That's it!

Never look at the sun through the pinhole. Your back should be toward the sun to protect your eyes. To brighten the image, simply move the back piece of cardboard closer to the pinhole. To see it larger, move the back cardboard farther away. Do not make the pinhole larger. It will only distort the crescent sun.

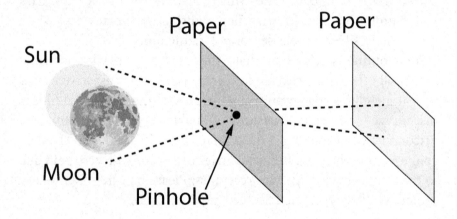

### WELDING GOGGLES

Welding goggles that have a rating of fourteen or higher are another useful eclipse viewing tool. The goggles can be used to view the solar eclipse directly. Do not use the goggles to look through binoculars or telescopes, as the goggles could potentially shatter due to intense direct heat. Avoid long periods of gazing with the goggles. Look away every so often. Give your eyes a break.

### SOLAR FILTERS FOR TELESCOPES

The ONLY safe way to view solar eclipses using telescopes or binoculars is to use solar filters. The filters are coated with metal

to diminish the full intensity of the sun. Although the filters can be expensive, it is better to purchase a quality filter rather than an inexpensive one that could shatter or melt from the heat.

The filters attach to the front of the telescope for easy viewing. Remember to give your telescope cooling breaks. Rapid heating can damage your equipment with or without filters attached.

### Watch Out for Unsafe Filters

There are several myths surrounding solar filters for eclipse viewing. In order for filters to be safe, they must be specially designed for looking at a solar eclipse. The following are all unsafe for eclipse viewing and can lead to retinal damage: developed colored or chromogenic film, black-and-white negatives such as X-rays, CDs with aluminum, smoked glass, floppy disk covers, black-and-white film with no silver, sunglasses, or polarizing films.

Some online articles state that using developed black-and-white film is safe. Those articles fail to mention the film must have a layer of real metallic silver to protect your eyes. Using developed film is discouraged. You cannot ensure the quality of the film. Feeling no discomfort while looking at the partial solar eclipse does NOT mean your eyes are protected. Retinal damage can occur with zero pain due to the retinas having no pain receptors. Please be careful. Only use protective glasses certified for viewing the eclipse.

### Viewing with Binoculars

When viewing the eclipse with binoculars, it is important to use solar filters on both lenses until totality. Only then is it safe to remove the filter. As the sun becomes visible after totality, replace the filters for safe viewing. Protect your pupils. Remember to give your binoculars a cool-down break between viewings. They can overheat rapidly from being pointed directly at the sun even with filters attached.

### Planning Ahead

There are many things to keep in mind when viewing a total eclipse. It is important to plan ahead to get the most out of this extraordinary experience.

### UNDERSTANDING SUN POSITION

All compass bearings in this book are true north. All compasses point to Earth's magnetic north. The difference between these two measurements is called magnetic declination. The magnetic declination for North Carolina in August 2017 is:

**9° 9' W ± 0° 21' (for Raleigh)**

Subtract the declination from the azimuth bearing as given in the text, and set your compass to that direction.

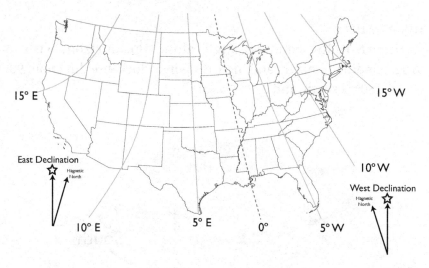

If you purchase a compass with a built-in declination adjustment, you can change the setting once and eliminate the calculations. The Suunto M-3G compass has this correction. A compass with a sighting mirror or wire will help you make a more accurate azimuth sighting.

The Suunto M-3G also has an inclinometer. This allows you to measure the elevation of any object above the horizon. Use this to figure out how high the sun will be above your position.

You can also use a smartphone inclinometer and compass for this purpose. Make sure to calibrate your smartphone's compass before every use, otherwise it might indicate the wrong bearing. Set the smartphone compass for true north to match the book. Understand the compass prior to August 21. There will be little time to guess or

search on Google. Smartphone and GPS compasses are "sticky." Their compasses don't swing as freely as a magnetic compass does.

The author has used his magnetic compass for azimuth measurements and a smartphone to measure elevation. Combining these two tools will allow you to make the best sightings possible.

Outdoor sporting goods stores in most towns and cities carry compasses. We recommend purchasing a good compass in your hometown. Take the time to learn how to use it before the day of the eclipse. You do not want to struggle with orienteering basics under pressure.

## Sun Azimuth

Azimuth is the compass angle along the horizon, with 0° corresponding to north, and increasing in a clockwise direction. 90° is east, 180° is south, and 270° is west.

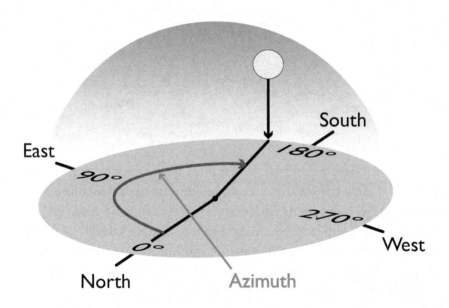

## Sun Elevation

Altitude is the sun's angle up from the horizon. A 0° altitude means exactly on the horizon and 90° means "straight up."

Using the sun azimuth and elevation data, you can predict the position of the sun at any given time. Positions given in this book coincide with the time of eclipse totality unless otherwise noted.

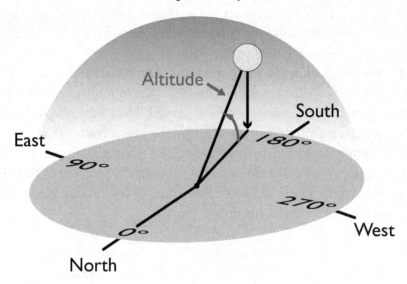

## ECLIPSE DATA FOR SELECT NORTH CAROLINA LOCATIONS

| LOCATION | TOTALITY START (EDT) |
|----------|----------------------|
| ANDREWS | 2:34:25PM |
| CASHIERS | 2:36:08PM |
| FRANKLIN | 2:35:22PM |
| HAYESVILLE | 2:34:44PM |
| MURPHY | 2:24:14PM |
| SYLVA | 2:35:50PM |

### ECLIPSE PHOTOGRAPHY

Photographing an eclipse is an exciting challenge, as the moon's shadow moves near 2,000MPH. There is an element of danger and the pressure of time. Looking at the unfiltered sun through a camera can permanently damage your vision and your camera. If you are unsure, just enjoy the eclipse with specially designed glasses. Keep a solar filter on your lens during the eclipse and remove for the duration of totality!

### Partial Vs. Total Solar Eclipse

To successfully and safely photograph a partial and total eclipse, it is important to understand the difference between the two. A solar eclipse occurs when the moon is positioned between the sun and Earth. The region where the shadow of the moon falls upon Earth's surface is where a solar eclipse is visible.

The moon's shadow has two parts—the penumbral shadow and the umbral shadow. The penumbral shadow is the moon's outer shadow where partial solar eclipses can be observed. Total solar eclipses can only be seen within the umbral shadow, the moon's inner shadow.

You cannot say you've seen a total eclipse when all you saw was a partial solar eclipse. It is like saying you've watched a concert, but in reality, you only listened outside the arena. In both cases, you have missed the drama and the action.

### Photographing A Partial And Total Solar Eclipse

Aside from the region where the outer shadow of the moon is cast, a partial solar eclipse is also visible before a total solar eclipse within

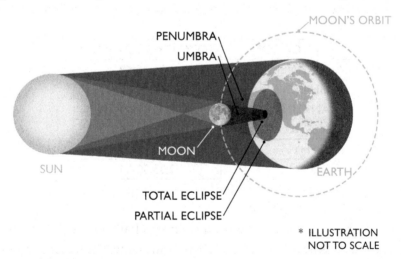

the inner shadow region. In both cases, it is imperative to use a solar filter on the lens for both photography and safety reasons. This is the only difference between taking a partial eclipse and a total eclipse photograph of the sun.

To photograph a total solar eclipse, you must be within the Path of Totality, the surface of the Earth within the moon's umbral shadow.

## THE CHALLENGE

A total solar eclipse only lasts for a couple of minutes. It is brief, but the scenario it brings is unforgettable. Seeing the radiant sun slowly being covered by darkness gives the spectator a high level of anticipation and indescribable excitement. Once the moon completely covers the sun's radiance, the corona is finally visible. In the darkness, the sun's corona shines, capturing the crowd's full attention. Watching this phenomenon is a breathtaking experience.

Amidst all the noise, cheering, and excitement, you have less than 150 seconds to take a perfect photograph. The key to this is planning. You need to plan, practice, and perfect what you will do when the big moment arrives because there is no replay. The pressure is enormous. You only have two minutes to capture the totality and the sun's corona using different exposures.

## PLAN, PRACTICE, PERFECT

It is important to practice photographing before the actual phenomenon arrives. Test your chosen imaging setup for flaws. Rehearse over and over until your body remembers what you will do from the moment you arrive at your chosen spot to the moment you pack up and leave the area.

You will discover potential problems regarding vibrations and focus that you can address immediately. This minimizes the variables that might affect your photographs at the most critical moment.

It's common for experienced eclipse chasers to lose track of what they plan to do. Write down what you expect to do. Practice it time and again. Play annoying, distracting music while you practice. Try photographing in the worst weather possible. Do anything you can to practice under pressure. Eclipse day is not the time to practice.

Once the sun is completely covered, don't just take photographs. Capture the experience and the image of the total solar eclipse in your mind as well. Set up cameras around you to record not just the total solar eclipse but also the excitement and reaction of the crowd.

## ECLIPSE PHOTOGRAPHY GEAR

What do you need to photograph the total eclipse? There are only a few pieces of equipment that you'll need. Preparing to photograph an eclipse successfully takes time. Not only do you have to be skilled and have the right gear, you have to be in the correct place.

## BASIC ECLIPSE PHOTOGRAPHY EQUIPMENT

- Solar viewing glasses
- Lens solar filter
- Minimum 300mm lens
- Stable tripod that can be tilted to 60° vertical
- High-resolution DSLR
- Spare batteries for everything
- Secondary camera to photograph people, the horizon, etc.
- Remote cable or wireless release

## ADDITIONAL ITEMS

- Video camera
- Video camera tripod
- Quality pair of binoculars
- Solar filters for each binocular lens
- Photo editing software

## EQUIPMENT TO PREPARE BEFORE THE BIG DAY

### A. Solar viewing glasses
You need a pair of solar viewing glasses as the eclipse approaches.

### B. Solar Filter
Partial and total eclipse photography is different from normal photography. Even if only 1% of the sun's surface is visible, it is still approximately 10,000 times brighter than the moon. Before totality, use a solar filter on your lens. Do not look at the sun with your eyes. It can cause irreparable damage to your retinas.

DO NOT leave your camera pointed at the sun without a solar filter attached. The sun will melt the inside of your camera. Think of a magnifying glass used to torch ants and multiply that by one hundred.

### C. Lens

To capture the corona's majesty, you need to use a telescope or a telephoto lens. The best focal length, which will give you a large image of the sun's disk, is 400mm and above. You don't want to waste all your efforts by bringing home a small dot where the black disk and majestic corona are supposed to be.

### D. Tripod

Bring a stable enough tripod to support your camera properly to avoid unsteady shots and repeated adjustments. Either will ruin your photos. It also needs to be portable in case you need to change locations for a better shot.

### E. Camera

You need to remember to set your camera to its highest resolution to capture all the details. Set your camera to:

- 14-bit RAW is ideal, otherwise
- JPG, Fine compression, Maximum resolution

Bracket your exposures. Shoot at various shutter speeds to capture different brightnesses in the corona. Note that stopping your lens all the way down may not result in the sharpest images.

Choose the lowest possible ISO for the best quality while maintaining a high shutter speed to prevent blurred shots. Set your camera to manual. Do not use AUTO ISO. Your camera will be fooled. The night before, test the focus position of your lens using a bright star or the moon.

Constantly double-check your focus. Be paranoid about this. You can deal with a grainy picture. No amount of Photoshop will fix a blurry, out-of-focus picture.

### F. Batteries

Remember to bring fresh batteries! Make sure that you have enough power to capture the most important moments. Swap in fresh batteries thirty minutes before totality.

### G. Remote release

Use a wired or wireless remote release to fire the camera's shutter. This will reduce the amount of camera vibration.

### H. Video Camera

Run a video camera of yourself. Capture all the things you say and do during the totality. You'll be amazed at your reaction.

### I. Photo editing software

You will need quality photo editing software to process your eclipse images. Adobe Lightroom and Photoshop are excellent programs to extract the most out of your images. Become well versed in how to use them at least a month before the eclipse.

### J. Smartphone applications

The following smartphone applications will aid in your photography planning: Wunderground, Skyview, Photographer's Ephemeris, Sunrise and Sunset Calculator, SunCalc, and Sun Surveyor among others.

### CAMERA PHONES

Smartphone cameras are useful for many things but not eclipse photography. An iPhone 6 camera has a 63° horizontal field of view and is 3264 pixels across. If you attempt to photograph the eclipse, the sun will be a measly 30-40 pixels wide depending on the phone. Digital pinch zoom won't help here. If you want *National Geographic* images, you'll need a serious camera and lens, far beyond any smartphone.

Consider instead using a smartphone to run a time-lapse of the entire event. The sun will be minuscule when shot on a smartphone. Think of something else exciting and interesting do to with it. Purchase a Gorilla Pod, inexpensive tripod, or selfie stick and mount the smartphone somewhere unique.

Also, partial and total eclipse light is strange and ethereal. Consider using that light to take unique pictures of things and people. It's rare and you may have something no one else does.

## FOCAL LENGTH & THE SIZE OF SUN

The size of the sun in a photo depends on the lens focal length. A 300mm lens is the recommended minimum on a full-frame (FF) DSLR. Lenses up to this size are relatively inexpensive. For more magnification, use an APS-C (crop) size sensor. Cameras with these sensors provide an advantage by capturing a larger sun.

For the same focal length, an APS-C sensor will provide a greater apparent magnification of any object. As a consequence, a shorter, less expensive lens can be used to capture the same size sun.

The below figure shows the size of the sun on a camera sensor at various focal lengths. As can be seen with the 200mm lens, the sun is quite small. On a full-frame camera at 200mm, the sun will be 371 pixels wide on a Nikon D810, a 36-megapixel body. A lower resolution FF camera will result in an even smaller sun.

Printing a 24-inch image shot on a Nikon D810 with a 200mm lens at a standard 300 pixels per inch results in a small sun. On this size paper, the sun will be a miserly 1.25 inches wide!

Photographing the eclipse with a lens shorter than 300mm will leave you with little to work with. Using a 400mm lens and printing a 24-inch print will result in a 2.5-inch-wide sun. For as massive as the sun is, it is a challenge to take a photograph with the sun of any meaningful size.

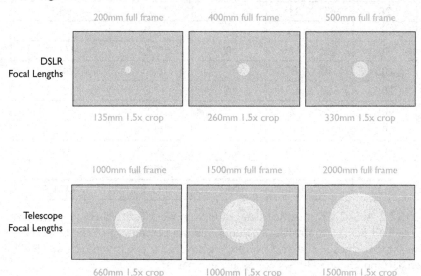

| FOCAL LENGTH | FOV FULL FRAME | FF VERT. ANGLE | % OF FF | SUN PIXEL SIZE |
|---|---|---|---|---|
| 14 | 104° X 81° | 81° | 0.7% | 32.1 |
| 20 | 84° X 62° | 62° | 0.9% | 41.9 |
| 28 | 65° X 46° | 46° | 1.2% | 56.5 |
| 35 | 54° X 38° | 38° | 1.4% | 68.5 |
| 50 | 40° X 27° | 27° | 2.0% | 96.4 |
| 105 | 19° X 13° | 13° | 4.1% | 200.2 |
| 200 | 10° X 7° | 7° | 7.6% | 371.9 |
| 400 | 5° X 3.4° | 3.4° | 15.6% | 765.6 |
| 500 | 4° X 2.7° | 2.7° | 19.6% | 964.2 |
| 1000 | 2° X 1.3° | 1.3° | 40.8% | 2002.5 |
| 1500 | 1.4° X 0.9° | 0.9° | 58.9% | 2892.6 |
| 2000 | 1° X 0.68° | 0.68° | 77.9% | 3828.4 |

Chart 1: Full-frame camera field of view. The 3rd column is the vertical field of view in degrees. Column 4 is the percentage of the total sensor height that the sun covers. Column 5 is how many pixels wide the sun will be on a 36MP Nikon D810. (Values are estimates)

| FOCAL LENGTH | FOV CROP | CROP VERT DEG | % OF CROP | SUN PIXEL SIZE |
|---|---|---|---|---|
| 14 | 80° X 58° | 58° | 0.9% | 33.9 |
| 20 | 61° X 43° | 43° | 1.2% | 45.8 |
| 28 | 45° X 31° | 31° | 1.7% | 63.5 |
| 35 | 37° X 25° | 25° | 2.1% | 78.7 |
| 50 | 26° X 18° | 18° | 2.9% | 109.3 |
| 105 | 13° X 8° | 8° | 6.6% | 245.9 |
| 200 | 6.7° X 4.5° | 4.5° | 11.8% | 437.2 |
| 400 | 3.4° X 2° | 2° | 26.5% | 983.7 |
| 500 | 2.7° X 1.8 | 1.8° | 29.4% | 1093.0 |
| 1000 | 1.3° X 0.9° | 0.9° | 58.9% | 2186.0 |
| 1500 | 0.9° X 0.6° | 0.6° | 88.3% | 3278.9 |
| 2000 | 0.6° X 0.45° | 0.5° | 117.8% | 4371.9 |

Chart 2: APS-C Crop sensor camera field of view. The 3rd column is the vertical field of view in degrees. Column 4 is the percentage of the total sensor height that the sun covers. Column 5 is how many pixels wide the sun will be on a 12mp Nikon D300s. (Values are estimates)

The big challenge is the cost of the lens. Lenses longer than 300mm are expensive. They also require heavier tripods and specialized tripod heads. The 70-300mm lenses from Nikon, Canon, Tamron, and others are relatively affordable options. It is worth spending time at a local camera shop to try different lenses. Long focal-length lenses are a significant investment, especially for a single event.

To achieve a large eclipse image, you will need a long focal-length lens, ideally at least 400mm. A standard 70-300mm lens set to 300mm will show a small sun. At 500mm, the sun image becomes larger and covers more of the sensor area. The corona will take up a significant portion of the frame. By 1000mm, the corona will exceed the capture area on a full-frame sensor. See the picture on page thirty-seven for sun size simulations for different focal lengths.

### SUGGESTED EXPOSURES

To photograph the partial eclipse, the camera must have a solar filter attached. If not, the intense light from the sun may damage (fry) the inside of your camera. This has happened to the author. The exposure depends on the density (darkness) of the solar filter used.

As a starting point, set the camera to ISO 100, f/8, and with the solar filter on, try an exposure of 1/4000. Make adjustments based on the histogram and highlight warning.

Turn on the highlight warning in your camera. This feature is commonly called "blinkies." This warning will help you detect if the image is overexposed or not.

Once the Baily's Beads, prominences, and corona become visible, there will only be 2.25 minutes to take bracketed shots. It will take at least eleven shots to capture the various areas of the sun's corona. The brightness varies considerably. No commercially available camera can capture the incredible dynamic range of the different portions of the delicate corona. This requires taking multiple photographs and digitally combining them afterward.

During totality, try these exposure times at ISO 100 and f/8:

1/4000, 1/2000, 1/1000, 1/250, 1/60, 1/30, 1/15, 1/4, 1/2, 1 sec, and 4 sec.

## PHOTOGRAPHY TIME

Set the camera to full-stop adjustments. It will reduce the time spent fiddling. As an example, the author tried the above shot sequence, adjusting the shutter speed as fast as possible.

It took thirty-three seconds to shoot the above 11 shots using 1/3-stop increments. This was without adjusting composition, focus, or anything else but the shutter speed. When the camera was set to full stop increments, it only took twenty-two seconds to step through the same shutter speed sequence.

Assuming the totality lasts less than two minutes, only four shot sequences could be made using 1/3-stop increments. Yet six shot sequences could be made when the camera was set to full stop steps. Zero time was spent looking at the back LCD to analyze highlights and the histogram.

Now add in the bare minimum time to check the highlight warning. It took sixty-three seconds to shoot and check each image using full stops. And that was without changing the composition to allow for sun movement, bumping the tripod, etc. Looking at the LCD ("chimping") consumed **half** of the totality time.

This test was done in the comfort of home under no pressure. In real world conditions, it may be possible to successfully shoot only one sequence. If you plan to capture the entire dynamic range of the totality, you must practice the sequence until you have it down cold. If you normally fumble with your camera, do not underestimate the difficulty, frustration, and stress of total eclipse photography.

Most importantly, trying to shoot this sequence allowed for zero time to simply look at the totality to enjoy the spectacle.

## AVOID LAST MINUTE PURCHASES

You should purchase whatever you think you'll need to photograph the eclipse today. This event will be nothing short of massive. Remember the hot toy of the year? Multiply that frenzy by a thousand. Everyone will want to try to capture their own photo.

Do not wait until the last few weeks before the eclipse to purchase cameras, lenses, filters, tripods, viewing glasses, and associated material. Consider that the totality of the eclipse will streak from

coast to coast. Everyone who wants to photograph the eclipse will order at the same time. If you wait until August to buy what you need, it's conceivable that every piece of camera equipment capable of creating a total eclipse photo will be sold out in the United States. Whether this happens or not, do not wait until midsummer to make your purchases. It may be too late.

## PRACTICE

You will need to practice with your equipment. Things may go wrong that you don't anticipate. If you've never photographed a partial or total eclipse, taking quality shots is more difficult than you think. Practice shooting the sequence with a midday sun. This will tell you if you have your exposures and timing correct. Figure out what you need well in advance.

Practice photographing the full moon and stars at night. Capture the moon in full daylight. There will be six moon cycles to practice with. Astrophotography is challenging and requires practice.

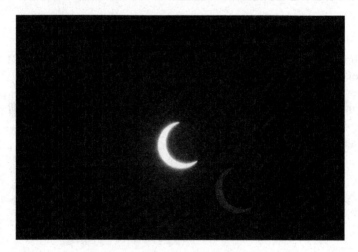

The May 20, 2012, eclipse as seen in San Diego, CA, shot with a Nikon D300s (crop sensor) with an 80-400mm lens set to ~350mm. The sun is 560 pixels wide on the 4288x2848 image.

This image is shown straight out of the camera without modification. Even with a high-quality camera and lens, photographing an eclipse is challenging. Note the haze and reflection from the overexposed sun.

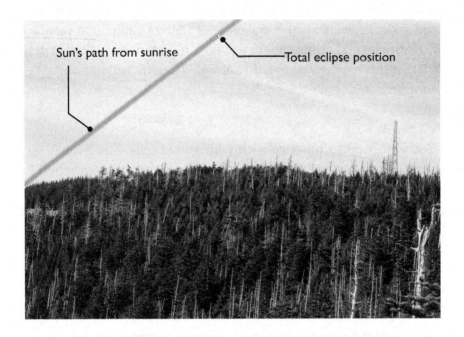

The sun will follow this path on the morning of the eclipse on August 21, 2017. Image of Great Smoky National Park, North Carolina.

*Note that this image is a simulation and approximation of where the total eclipse will appear. Refer to the eclipse position data for a more accurate location.*

⊚ is the symbol for the sun and first appeared in Europe during the Renaissance.
☾ is the ancient symbol for the moon.

# Viewing Locations Around North Carolina

Hundreds of thousands of people will travel to and around North Carolina to view the total eclipse. The skies are partly clear, and there is a vast amount of space to view the total eclipse from.

If the weather is questionable, seek out a new location as soon as possible. If you wait until the hour before the eclipse, you may find yourself stuck in traffic, as others will be looking for clear skies. Be safe on the roadways, as drivers may be distracted.

This section contains popular, alternative, and little-known locations to watch the eclipse. As long as there are no clouds or smoke from fires, the partial eclipse will be viewable from anywhere in the state.

## SUGGESTED TOTAL ECLIPSE VIEW POINTS

### TOWNS AND CITIES

- Andrews
- Bryson City
- Cashiers
- Dillsboro
- Fontana Village
- Franklin
- Glenville
- Hayesville
- Highlands
- Murphy
- Proctor
- Robbinsville
- Sapphire
- Sylva

Raleigh

North Carolina
Total Eclipse Path

### UNIQUE LOCATIONS

- Fontana Lake
- Great Smoky Mountains NP
- Joyce Kilmer Memorial Forest
- Lake Santeetlah
- Nantahala Lake
- Nantahala NF

## ANDREWS

| | |
|---|---|
| Elevation: | 1,781 feet |
| Population: | 1,762 |
| Main road/hwy: | US 74 |

Andrews

### OVERVIEW

Quietly nestled in the heart of the Smoky Mountains, Andrews is a nature lover's dream. With its unspoiled streams, mountains, and rivers, there's no shortage of places to explore. However, this doesn't mean it's in the middle of nowhere. Andrews also boasts a thriving town with several restaurants, breweries, and galleries. On day of the eclipse, the city of Andrews is holding a festival in town. Sponsored by local breweries, this festival will include tasty food, entertaining music, and fine drinks.

### GETTING THERE

Drive west from Asheville on I-40 until you merge onto US 74. Continue on Highway 19 to reach Andrews.

### TOTALITY DURATION

2 minutes 38 seconds

### NOTES

Visit the town's website for more information about the eclipse at www.andrewsnc.com/event/get-eclipsed-in-andrews-we-are-on-the-center-line/?instance_id=7.

| Event | Time (EDT) | Altitude | Azimuth |
|---|---|---|---|
| Sunrise | 6:59:00AM | 0° | 74° |
| Eclipse Start | 1:05:43PM | 65° | 160° |
| Totality Start | 2:34:25PM | 63° | 212° |
| Totality End | 2:37:03PM | 63° | 213° |
| Eclipse End | 4:00:13PM | 50° | 242° |
| Sunset | 8:16:00PM | 0° | 285° |

# BRYSON CITY

| | |
|---|---|
| Elevation: | 1,752 feet |
| Population: | 1,424 |
| Main road/hwy: | US 19 |

Bryson City

## OVERVIEW

Bryson City is a small town with a vibrant community that, like most small American towns, centers along its main street. Bryson is going to have a four-day festival from the dusk of Friday until the eclipse on Monday to celebrate and view the total eclipse. This event will not only include live music at Riverfront Park but will feature a block party, food trucks, tailgating, and even train rides to scenic locations all happening the day of the eclipse.

## GETTING THERE

Drive northeast from Andrews on US 74 and continue on US 19 to reach Bryson City.

## TOTALITY DURATION

1 minute 58 seconds

## NOTES

Visit this website for more eclipse information around Bryson City: www.greatsmokies.com/2017eclipse.html.

| Event | Time (EDT) | Altitude | Azimuth |
|---|---|---|---|
| Sunrise | 6:58:00AM | 0° | 74° |
| Eclipse Start | 1:06:22PM | 65° | 161° |
| Totality Start | 2:35:12PM | 63° | 212° |
| Totality End | 2:37:10PM | 62° | 213° |
| Eclipse End | 4:00:23PM | 49° | 243° |
| Sunset | 8:15:00PM | 0° | 285° |

# CASHIERS

| | |
|---|---|
| Elevation: | 1,974 feet |
| Population: | 3,484 |
| Main road/hwy: | US 64 |

Cashiers

## OVERVIEW

Known as "The Heart of the Blue Ridge Mountains," Cashiers is a little village in Jackson County. Its serene landscape is perfect for anyone wanting to get away from big city life, if only for a weekend. What makes Cashiers unique is that its population grows tremendously in the spring and summer as part-time residents flock to their homes in the village to enjoy some outdoor fun and for a round of golf before or after the eclipse.

## GETTING THERE

Drive east from Franklin on US 64 for twenty-eight miles to reach Cashiers.

## TOTALITY DURATION

2 minutes 22 seconds

## NOTES

Visit Cashiers' website for updated eclipse information at www. cashiersnorthcarolina.org.

| Event | Time (EDT) | Altitude | Azimuth |
|---|---|---|---|
| Sunrise | 6:57:00AM | 0° | 74° |
| Eclipse Start | 1:07:24PM | 65° | 163° |
| Totality Start | 2:36:08PM | 63° | 214° |
| Totality End | 2:38:30PM | 62° | 215° |
| Eclipse End | 4:01:26PM | 49° | 243° |
| Sunset | 8:13:00PM | 0° | 285° |

# DILLSBORO

| | |
|---|---|
| Elevation: | 1,975 feet |
| Population: | 232 |
| Main road/hwy: | US 74 |

Dillsboro

## OVERVIEW

Dillsboro is a popular tourist stop on the way to the Smoky Mountains. Though only two blocks long, Dillsboro is home to many artisan shops, art galleries, and restaurants. Located near the Great Smoky Mountain National Park, this village is just minutes from all the activities that can be found there. To celebrate the total eclipse, Dillsboro is holding an arts and crafts festival where several dozen artisans will be displaying and demonstrating their craft.

## GETTING THERE

Drive north from Franklin on US 23 for eighteen miles to reach Dillsboro.

## TOTALITY DURATION

1 minute 47 seconds

## NOTES

Visit the Dillsboro website for updated eclipse information at www.dillsboronc.info.

| Event | Time (EDT) | Altitude | Azimuth |
|---|---|---|---|
| Sunrise | 6:57:00AM | 0° | 74° |
| Eclipse Start | 1:06:51PM | 65° | 162° |
| Totality Start | 2:35:45PM | 62° | 213° |
| Totality End | 2:37:32PM | 62° | 214° |
| Eclipse End | 4:00:45PM | 49° | 243° |
| Sunset | 8:14:00PM | 0° | 285° |

# Fontana Village

Elevation: 1,919 feet
Main road/hwy: Hwy 28

Fontana Village

## Overview

Fontana Village is a luxurious resort that is almost hidden by the Nantahala National Forest. Built over sixty years ago as a town for the workers building Fontana Dam, this resort has grown into a must-go vacation spot. With dozens of fun activities to enjoy, there's never a dull moment. Fontana Village Resort will be holding a viewing party to celebrate the eclipse, complete with music and a barbecue cookout.

## Getting There

Drive north from Andrews on US 75, US 129, Highway 143, and Highway 28 to reach Fontana Village.

## Totality Duration

2 minutes 26 seconds

## Notes

Be prepared for limited services in Fontana Village during the eclipse weekend. Visit their website for more information and to make reservations at www.fontanavillage.com.

| Event | Time (EDT) | Altitude | Azimuth |
|---|---|---|---|
| Sunrise | 6:59:00AM | 0° | 74° |
| Eclipse Start | 1:05:32PM | 65° | 160° |
| Totality Start | 2:34:12PM | 63° | 211° |
| Totality End | 2:36:39PM | 63° | 212° |
| Eclipse End | 3:59:50PM | 50° | 242° |
| Sunset | 8:16:00PM | 0° | 285° |

# FRANKLIN

| | |
|---|---|
| Elevation: | 2,119 feet |
| Population: | 3,900 |
| Main road/hwy: | US 23 |

Franklin

## OVERVIEW

The town of Franklin will be hosting a special event to commemorate the eclipse. Known as the "Gem Capital of the World" due to its history of gem mining, Franklin sits amidst the Nantahala National Forest. Though small, there's never a shortage of things to do whether it's white-water rafting, taking a leisurely stroll through downtown, or stopping by the town's weekly Pickin' on the Square, a venue that features live music and plenty of food. There are also several events to enjoy throughout the year.

## GETTING THERE

Drive southwest from Asheville on I-40, merge onto US 74, and continue on US 23 to reach Franklin.

## TOTALITY DURATION

2 minutes 29 seconds

## NOTES

The Franklin website will have updated eclipse information. Visit it at www.franklinnc.com.

| Event | Time (EDT) | Altitude | Azimuth |
|---|---|---|---|
| Sunrise | 6:58:00AM | 0° | 74° |
| Eclipse Start | 1:06:41PM | 65° | 162° |
| Totality Start | 2:35:22PM | 63° | 213° |
| Totality End | 2:37:52PM | 62° | 214° |
| Eclipse End | 4:00:52PM | 49° | 243° |
| Sunset | 8:14:00PM | 0° | 285° |

# GLENVILLE

| | |
|---|---|
| Elevation: | 3,494 feet |
| Population: | 100 |
| Main road/hwy: | Hwy 107 |

Glenville

## OVERVIEW

Glenville is a small collection of homes in Jackson County. It was actually destroyed in 1941 after the hydroelectric dam was built that formed Lake Glenville from the Tuckasegee River. It has been rebuilt and is now a very popular tourist destination. People come to Glenville to buy accommodating vacation homes. In fact, there are several multimillion-dollar homes that sit at the lakeside. Lake Glenville is perfect for watersports and is a popular spot for fishermen of smallmouth bass. The lake will help cool the air for a better view of the eclipse.

## GETTING THERE

Drive east from Franklin on Highway 28, then Walnut Creek Road, and on Pine Creek Road to Highway 107 to reach Glenville.

## TOTALITY DURATION

2 minutes 16 seconds

## NOTES

Be prepared for limited services in Glenville during the eclipse weekend.

| Event | Time (EDT) | Altitude | Azimuth |
|---|---|---|---|
| Sunrise | 6:57:00AM | 0° | 74° |
| Eclipse Start | 1:07:17PM | 65° | 162° |
| Totality Start | 2:36:02PM | 62° | 214° |
| Totality End | 2:38:19PM | 62° | 215° |
| Eclipse End | 4:01:17PM | 49° | 243° |
| Sunset | 8:13:00PM | 0° | 285° |

# Hayesville

| | |
|---|---|
| Elevation: | 1,893 feet |
| Population: | 348 |
| Main road/hwy: | US 64 |

Hayesville

## Overview

Hayesville is a small town that's popular with tourists. There are several lakes and rivers that are perfect for boating and kayaking. Located in Clay County near several mountains, there are dozens of hiking and biking paths to explore. Hayesville also has a lot of historical sites, and in fact, their town hall is a historic courthouse and jail converted into a museum. History lovers will greatly enjoy a visit here.

## Getting There

Drive west from Franklin on US 64 to reach Hayesville.

## Totality Duration

2 minutes 32 seconds

## Notes

Be prepared for limited services in Hayesville during the eclipse weekend. Visit the community's website for updates on eclipse information at www.hayesville.org.

| Event | Time (EDT) | Altitude | Azimuth |
|---|---|---|---|
| Sunrise | 6:57:00AM | 0° | 74° |
| Eclipse Start | 1:05:53PM | 65° | 160° |
| Totality Start | 2:34:44PM | 63° | 212° |
| Totality End | 2:37:16PM | 63° | 213° |
| Eclipse End | 4:00:31PM | 50° | 243° |
| Sunset | 8:13:00PM | 0° | 285° |

# HIGHLANDS

| | |
|---|---|
| Elevation: | 4,118 feet |
| Population: | 924 |
| Main road/hwy: | US 64 |

Highlands

## OVERVIEW

In Macon County sits a little village with a large cultural landscape. Highlands boasts a performing arts center and historic playhouse where visitors can catch live music and food. Several bards and restaurants call this town home that features locally grown cuisine. Highlands also has no shortage of nature. Surrounded by forests, lakes, and waterfalls, there something for everyone to do here. If you feel like shopping before or after the eclipse, Highlands has several artisan shops to explore, each filled with unique offerings you won't find anywhere else.

## GETTING THERE

Drive southeast from Franklin on Highway 28, merge onto US 23, and then continue on US 64 to reach Highlands.

## TOTALITY DURATION

2 minutes 32 seconds

## NOTES

Visit the Highlands Chamber of Commerce website for more information about events in the town at highlandschamber.org.

| Event | Time (EDT) | Altitude | Azimuth |
|---|---|---|---|
| Sunrise | 6:57:00AM | 0° | 74° |
| Eclipse Start | 1:07:13PM | 65° | 162° |
| Totality Start | 2:35:55PM | 63° | 214° |
| Totality End | 2:38:28PM | 62° | 215° |
| Eclipse End | 4:01:23PM | 49° | 243° |
| Sunset | 8:13:00PM | 0° | 285° |

# MURPHY

| | |
|---|---|
| Elevation: | 1,604 feet |
| Population: | 1,613 |
| Main road/hwy: | US 74 |

Murphy

## OVERVIEW

Murphy is the county seat of Cherokee County. Founded in 1835, this town is located in the heart of the Appalachians. Cherishing its history, Murphy is known for restoring historic buildings, but that doesn't mean there's nothing new. There are several shops and restaurants to enjoy in downtown, and if you like fishing, then you'll love Murphy's nearby streams absolutely bursting with trout. If you're looking for more strenuous activity, then there are plenty of places for hiking and mountain biking.

## GETTING THERE

Drive southwest for sixteen miles from Andrews on US 74 and US 19 to reach Murphy.

## TOTALITY DURATION

2 minutes 28 seconds

## NOTES

Murphy's website will have more information and updates on eclipse-related events. Visit it at townofmurphync.com/homepage.

| Event | Time (EDT) | Altitude | Azimuth |
|---|---|---|---|
| Sunrise | 7:00:00AM | 0° | 74° |
| Eclipse Start | 1:05:21PM | 65° | 159° |
| Totality Start | 2:34:14PM | 63° | 211° |
| Totality End | 2:36:43PM | 63° | 212° |
| Eclipse End | 4:00:06PM | 50° | 242° |
| Sunset | 8:16:00PM | 0° | 285° |

# PROCTOR

| | |
|---|---|
| Elevation: | 1,968 feet |
| Population: | Ghost town |
| Main road/hwy: | None |

Proctor

## OVERVIEW

Named after Moses Proctor, the first white settler to the area, the town of Proctor was once a mining boomtown located near Hazel creek. The town was flooded by the construction of the Fontana Dam, and many of the mines are submerged under water, appearing only when the surface of the lake is low. Much of the town, including the cemetery, remain above the water line and can only be reached by boat. Despite its destruction, it remains a popular tourist spot as a ghost town.

## GETTING THERE

Visit Fontana Village to find out how to reach Proctor by a charter boat or use your own watercraft.

## TOTALITY DURATION

2 minutes 15 seconds

## NOTES

Proctor has no known services. Be prepared to be self-contained to watch the eclipse from the ruins of Proctor.

| Event | Time (EDT) | Altitude | Azimuth |
|---|---|---|---|
| Sunrise | 6:59:00AM | 0° | 74° |
| Eclipse Start | 1:05:42PM | 65° | 160° |
| Totality Start | 2:34:25PM | 63° | 211° |
| Totality End | 2:36:41PM | 62° | 213° |
| Eclipse End | 3:59:53PM | 50° | 242° |
| Sunset | 8:16:00PM | 0° | 285° |

# ROBBINSVILLE

| | | |
|---|---|---|
| Elevation: | 2,044 feet | |
| Population: | 620 | |
| Main road/hwy: | US 129 | Robbinsville |

## OVERVIEW

The town of Robbinsville has events all weekend long to celebrate the eclipse. This includes a craft and antique fair on Saturday where local artists will show off their craft, then live music on Sunday, complete with coupons for many of the lovely restaurants that call Robbinsville home. After the eclipse, you can enjoy the natural scenery that surrounds the town and go hiking, fishing, or simply walk among the shops that line the streets.

## GETTING THERE

Drive northeast from Andrews on US 129/19/74 to Topton. Continue on US 129 northwest to reach Robbinsville.

## TOTALITY DURATION

2 minutes 34 seconds

## NOTES

Visit the town's website for updates on eclipse events at www.townofrobbinsville.com.

| Event | Time (EDT) | Altitude | Azimuth |
|---|---|---|---|
| Sunrise | 6:59:00AM | 0° | 74° |
| Eclipse Start | 1:05:39PM | 65° | 160° |
| Totality Start | 2:34:19PM | 63° | 211° |
| Totality End | 2:36:54PM | 63° | 213° |
| Eclipse End | 4:00:02PM | 50° | 242° |
| Sunset | 8:16:00PM | 0° | 285° |

## Sapphire

| | |
|---|---|
| Elevation: | 3,176 feet |
| Population: | 100 |
| Main road/hwy: | US 64 |

Sapphire

### Overview

Sapphire is a small village that boasts a lot of nature. There are dozens of activities to do here. You can visit the Whitewater Falls, one of the most beautiful waterfalls in the eastern United States. You can also enjoy hiking at Gorges State Park. This park's serene landscape is a must-see. You can visit the Whitewater Equestrian Center for riding lessons and equestrian hikes, or head to the Sapphire National Golf Club and enjoy a few links.

### Getting There

Drive east from Cashiers on US 64 for seven miles to reach Sapphire.

### Totality Duration

2 minutes 17 seconds

### Notes

Be prepared for limited services in Sapphire during the eclipse weekend. Visit the TripAdvisor web page to learn about more activities in Sapphire at www.tripadvisor.com/Attractions-g49513-Activities-Sapphire_Jackson_County_North_Carolina.html.

| Event | Time (EDT) | Altitude | Azimuth |
|---|---|---|---|
| Sunrise | 6:56:00AM | 0° | 74° |
| Eclipse Start | 1:07:36PM | 65° | 163° |
| Totality Start | 2:36:22PM | 62° | 214° |
| Totality End | 2:38:40PM | 62° | 215° |
| Eclipse End | 4:01:35PM | 49° | 244° |
| Sunset | 8:12:00PM | 0° | 285° |

# SYLVA

| | | |
|---|---|---|
| Elevation: | 2,036 feet | |
| Population: | 2,602 | |
| Main road/hwy: | US 74 | Sylva |

## OVERVIEW

Downtown Sylva is hosting a giant festival on the weekend preceding the eclipse, as well as on the day of the eclipse itself. There will be live music, including a performance by The Social, a variety dance band. As well, the local shops and restaurants are holding Moonlight Madness specials all weekend long. You can stop by to get special deals only available during the festival. On Monday, there will be an Eclipse Festival with a performance by Colby Deitz Band, along with food trucks and lectures by experts on eclipses.

## GETTING THERE

Drive southwest on US 74 from Waynesville for nineteen miles to reach Sylva.

## TOTALITY DURATION

1 minute 42 seconds

## NOTES

The Sylva website will have more information about events during the eclipse weekend. Visit it at www.sylvanc.govoffice3.com.

| Event | Time (EDT) | Altitude | Azimuth |
|---|---|---|---|
| Sunrise | 6:57:00AM | 0° | 74° |
| Eclipse Start | 1:06:54PM | 65° | 162° |
| Totality Start | 2:35:50PM | 62° | 213° |
| Totality End | 2:37:32PM | 62° | 214° |
| Eclipse End | 4:00:47PM | 49° | 243° |
| Sunset | 8:14:00PM | 0° | 285° |

# Fontana Lake

| | |
|---|---|
| Elevation: | 1,919 feet |
| Main road/hwy: | Hwy 28 |

Fontana Lake

## Overview

Surrounded by the Great Smoky Mountains, Fontana Lake is the largest lake in North Carolina. Fontana Lake is a popular tourist spot for boaters, fishermen, and lovers of water sports. For history lovers, you can check out the visitor center to learn more about the lake and Fontana Dam. If you enjoy hiking and camping, there are plenty of spots and paths to explore. If you're feeling extra adventurous, you can walk across the dam 480 feet up, the same height as a fifty-story skyscraper.

## Getting There

Use the same directions as Fontana Village.

## Totality Duration

2 minutes 22 seconds, depending on lake location.

## Notes

Visit the following website for more information about Fontana Lake and any eclipse events that might be happening: www.romanticasheville.com/fontana_lake.htm

*Times are for Fontana Village. Position on the lake will affect times.*

| Event | Time (EDT) | Altitude | Azimuth |
|---|---|---|---|
| Sunrise | 6:59:00AM | 0° | 74° |
| Eclipse Start | 1:05:32PM | 65° | 160° |
| Totality Start | 2:34:12PM | 63° | 211° |
| Totality End | 2:36:39PM | 63° | 212° |
| Eclipse End | 3:59:50PM | 50° | 242° |
| Sunset | 8:16:00PM | 0° | 285° |

# GREAT SMOKY MOUNTAINS NP

Elevation:          Various
Main road/hwy:      US 441

Great Smoky
Mountains NP

## OVERVIEW

It is possible to enjoy the total eclipse from the southwest section of America's most visited national park. Straddling the border between North Carolina and Tennessee, the park saw over eleven million recreational visits in 2016. This park offers one of the most impressive forest-viewing experiences in the country. The park is organizing events at Clingmans Dome, Cades Cove, and Oconaluftee. Do be aware that traffic during this event may come to a complete standstill. Plan accordingly.

## GETTING THERE

Drive north from Cherokee on US 441 to reach Great Smoky Mountains National Park.

## TOTALITY DURATION

Various

## NOTES

Note that only the southwest section of the national park will be inside the path of totality. Visit the park's website for more information about eclipse viewing at www.nps.gov/grsm/planyourvisit/2017-solar-eclipse.htm.

*Eclipse times for Clingmans Dome. Your location may vary.*

| Event | Time (EDT) | Altitude | Azimuth |
|-------|-----------|----------|---------|
| Sunrise | 6:58:00AM | 0° | 74° |
| Eclipse Start | 1:06:08PM | 65° | 161° |
| Totality Start | 2:35:11PM | 62° | 212° |
| Totality End | 2:36:33PM | 62° | 213° |
| Eclipse End | 4:00:03PM | 49° | 242° |
| Sunset | 8:15:00PM | 0° | 285° |

# Joyce Kilmer Memorial Forest

| | |
|---|---|
| Elevation: | Varies |
| Main road/hwy: | US 129 |

Joyce Kilmer
Memorial Forest

## Overview

Located near Robbinsville, the Joyce Kilmer Memorial Forest is an excellent example of Appalachian forest growth. There is an easy two-mile walk that shows the best of what this forest have to offer. But if you're a more rugged hiker, then there are several sites and trails perfect for you. Deeper into the forests, trails are minimally maintained with nothing but small, wooden signposts at forks. You'll need to know how to read a compass and map to navigate the dense foliage.

## Getting There

Drive to Robbinsville to access the Joyce Kilmer Memorial Forest.

## Totality Duration

Varies depending on location.

## Notes

For more information about the forest area, visit www.romanticasheville.com/joyce_kilmer_forest.htm.

*Times for Robbinsville. Location in the forest will affect times.*

| Event | Time (EDT) | Altitude | Azimuth |
|---|---|---|---|
| Sunrise | 6:59:00AM | 0° | 74° |
| Eclipse Start | 1:05:39PM | 65° | 160° |
| Totality Start | 2:34:19PM | 63° | 211° |
| Totality End | 2:36:54PM | 63° | 213° |
| Eclipse End | 4:00:02PM | 50° | 242° |
| Sunset | 8:16:00PM | 0° | 285° |

# LAKE SANTEETLAH

| | |
|---|---|
| Elevation: | 2,000 feet |
| Population: | 45 |
| Main road/hwy: | US 129 |

Lake Santeetlah

## OVERVIEW

In Graham County sits a tiny town on a peninsula surrounded by a lake of the same name. Lake Santeetlah is a city six miles north of Robbinsville and a stone's throw from Nantahala National Forest. During the summer, the town's population grows tenfold as part-time residents from Georgia and Florida come to enjoy boating, swimming, and fishing. Not only that, but there are dozens of campsites along the lake shores, making it perfect for campers looking for some peace and quiet.

## GETTING THERE

Drive to Robbinsville, then continue for six miles north on US 129.

## TOTALITY DURATION

2 minutes 34 seconds

## NOTES

Be prepared for limited services in Lake Santeetlah during the eclipse weekend. Visit the village website for more information at www.townoflakesanteetlah.org.

| Event | Time (EDT) | Altitude | Azimuth |
|---|---|---|---|
| Sunrise | 6:59:00AM | 0° | 74° |
| Eclipse Start | 1:05:31PM | 65° | 160° |
| Totality Start | 2:34:10PM | 63° | 211° |
| Totality End | 2:36:44PM | 63° | 212° |
| Eclipse End | 3:59:53PM | 50° | 242° |
| Sunset | 8:16:00PM | 0° | 285° |

# NANTAHALA LAKE

| Elevation: | 3,000 feet |
| Main road/hwy: | Wayah Rd. |

Lake Nantahala

## OVERVIEW

Nantahala Lake has many elevated vistas that make for perfect spots to view the eclipse. Located above the Nantahala River Gorge, the lake is a very popular spot among fishers. Chock-full of walleye, crappie, trout, and bass, Nantahala Lake is the perfect spot to cast your line and see what bites. Nantahala Lake also has a marina where you can rent a pontoon for the day and explore. The lake is also perfect for white-water sports like kayaking and rafting.

## GETTING THERE

Drive to the town of Aquone from Nantahala to reach the lake. Refer to local authorities for an update on road conditions.

## TOTALITY DURATION

2 minutes 37 seconds

## NOTES

Be prepared for limited services at the lake during the eclipse weekend. Visit the lake's website for updated information at www. visitnantahalanc.com/index.html.

| Event | Time (EDT) | Altitude | Azimuth |
|---|---|---|---|
| Sunrise | 6:59:00AM | 0° | 74° |
| Eclipse Start | 1:06:06PM | 65° | 161° |
| Totality Start | 2:34:47PM | 63° | 212° |
| Totality End | 2:37:25PM | 63° | 213° |
| Eclipse End | 4:00:30PM | 50° | 243° |
| Sunset | 8:15:00PM | 0° | 285° |

# Nantahala National Forest

| | |
|---|---|
| Elevation: | Varies |
| Main road/hwy: | US 74 |

Nantahala NF

## Overview

Nantahala is a Cherokee word meaning Land of the Noonday Sun, so called because the forest is full of deep valleys and tall mountains that in certain places the ground experiences no sunlight except when the sun is directly above. Get lost in the serene mountain scenery as you explore this gem of a national park. Not only are there places to go camping, fishing, and picnicking, but the more adventurous types can have fun white-water rafting.

## Getting There

Drive to the town of Nantahala as one of the access points for the national forest.

## Totality Duration

Varies, mean time 2 minutes 32 seconds

## Notes

Visit the following websites for more information about the forest:
www.romanticasheville.com/nantahala_forest.htm
www.fs.usda.gov/recarea/nfsnc/recarea/?recid=48634

| Event | Time (EDT) | Altitude | Azimuth |
|---|---|---|---|
| Sunrise | 6:59:00AM | 0° | 74° |
| Eclipse Start | 1:06:15PM | 65° | 161° |
| Totality Start | 2:34:56PM | 63° | 212° |
| Totality End | 2:37:28PM | 62° | 213° |
| Eclipse End | 4:00:23PM | 50° | 243° |
| Sunset | 8:15:00PM | 0° | 285° |

Paste a meaningful picture of your eclipse experience, perhaps a photo of you and the people you watched it with. This will help you remember your family, friends, and companions.

# Remember the North Carolina Total Eclipse
## August 21, 2017

Who was I with? _____

_____

_____

_____

_____

What did I see? _____

_____

_____

_____

_____

_____

_____

_____

What did I feel? _____

_____

_____

_____

_____

_____

_____

_____

_____

_____

_____

_____

What did the people with me think? _____

_____

_____

_____

_____

_____

_____

_____

_____

Where did I stay? _____

_____

_____

_____

_____

_____

_____

_____

## Enjoy other Sastrugi Press titles

*2017 Total Eclipse State Series* by Aaron Linsdau
Sastrugi Press has published several state-specific guides to the 2017 total eclipse crossing over the United States. Check the Sastrugi Press website for the various state eclipse books: www.sastrugipress.com/eclipse/

*Antarctic Tears* by Aaron Linsdau
What would make someone give up a high-paying career to ski alone across Antarctica to the South Pole? This inspirational true story will make readers both cheer and cry. Fighting skin-freezing temperatures, infections, and emotional breakdown, Aaron Linsdau exposes the harsh realities of the world's largest wilderness. Discover what drives someone to the brink of destruction while pursuing a dream.

*Adventure One* by Aaron Linsdau and Terry Williams, M.D.
What does it take to conceptualize, plan, and enjoy your first expedition? This inspirational book contains hard-won knowledge from both authors about their experiences on expeditions around the world. The information provided in this book is useful whether you plan to climb a high peak, cross a polar plateau, or set out on a never before attempted new trek. (*Available Summer 2017*)

*Lost at Windy Corner* by Aaron Linsdau
Climbing Denali is a treacherous affair. Avalanches, blinding blizzards, and crevasses have killed experienced teams. What happens when someone decides to climb the mountain solo? In this dramatic story, Aaron describes the choices made and the lessons that were learned as a result. This is more than an adventure story. It teaches defining success on your own terms in business and life. The messages will stay with you long after the end of the book. (*Available Summer 2017*)

Visit Sastrugi Press on the web at www.sastrugipress.com to purchase the above titles in bulk. They are also available from your local bookstore or online retailers in print, e-book, or audiobook form.

<div align="center">

Thank you for choosing Sastrugi Press.
*"Turn the Page Loose"*

</div>

## About Aaron Linsdau

Aaron Linsdau is a polar explorer and motivational speaker. He energizes audiences with life and business lessons that stick. He delivers a message of courage by building grit and maintaining a positive attitude. Aaron teaches audiences how to eat two sticks of butter a day to achieve their goal. He shares how to build resilience to deal with constant pressure and adrenaline overload.

He holds the world record for the longest expedition in days from Hercules Inlet to the South Pole. Aaron is the second only American to complete the trip alone.

This solo expedition is more difficult than climbing Mount Everest with a team. Being alone dramatically increases the challenge. Aaron uses emotionally stirring stories to show how to overcome obstacles, impossible challenges, and unimaginable conditions. He relates these stories to business challenges and shows how the common person can achieve uncommon results.

Aaron collaborates with organizations to deliver the right message for the audience. He relates his experiences to business realities. Aaron loves inspiring audiences. Book Aaron for your next event today.

### *"Never Give Up"*
Grit • Courage • Attitude • Perseverance • Resilience

Learn more about Aaron Linsdau at:
www.aaronlinsdau.com or www.ncexped.com.

Aaron at the South Pole after 82 days alone in Antarctica.

Smartphone link

CPSIA information can be obtained
at www.ICGtesting.com
Printed in the USA
FSOW04n1154200717
36563FS

9 781944 986148